**ALLIANCE FOR THE ARTS
IN RESEARCH UNIVERSITIES**

Copyright © 2020 by the Regents of the University of Michigan

Some rights reserved

This work is licensed under the Creative Commons Attribution-ShareAlike 4.0 International License.

To view a copy of this license, visit http://creativecommons.org/licenses/by-sa/4.0/ or send a letter to Creative Commons, PO Box 1866, Mountain View, California, 94042, USA.

Published in the United States of America by
Michigan Publishing
Manufactured in the United States of America

DOI: https://doi.org/10.3998/mpub.11660694

ISBN 978-1-60785-630-6 (paper)
ISBN 978-1-60785-631-3 (open-access)

# A2RU PARTNER UNIVERSITIES

Boston University
Dartmouth College
James Madison University
Johns Hopkins University
Kent State University
Louisiana State University
Massachusetts Institute of Technology
Michigan State University
Northeastern University
Oregon State University
Penn State
Pontificia Universidad Católica de Chile
Princeton University
Rochester Institute of Technology
Texas Tech University
Tufts University
The University of Alabama
The University of Alabama at Birmingham
University of Arkansas
University of Cincinnati
University of Colorado Boulder
University of Florida
University of Georgia
University of Houston
University of Illinois at Urbana-Champaign
University of Iowa
University of Kansas
University of Maryland
University of Michigan
University of Nebraska-Lincoln
University of Nevada, Las Vegas
University of North Texas
University of Texas at Dallas
University of Utah
University of Virginia
University of Wisconsin-Madison
Virginia Commonwealth University
Virginia Tech

The Alliance for the Arts in Research Universities (a2ru) is a partnership of over 40 institutions committed to ensuring the greatest possible institutional support for the full spectrum of arts and arts-integrative research, curricula, programs, and creative practice for the benefit of all students and faculty at research universities and the communities they serve.

IMPACTS OF ARTS INTEGRATION & INTERDISCIPLINARY PRACTICE

# A2RU Research to Practice

Where the arts have a lively presence on campus, and interact with other disciplines as well as across the boundaries of the university, we find a range of impacts. Some of them are high-level—recurring and broadly applicable—while others are specific to a particular group or field. This report presents a synthesis of our research findings on the impacts of the arts and interdisciplinary practice on student skills and capacities. Companion reports recount the impacts we found in other areas and for other populations.

Our taxonomy of impacts is built on examples that surfaced from interview and survey data, and on a review of the literature. Some impacts are verified with experimental studies and some are anecdotal or aspirational; thus, we consider this a taxonomy of the potential impacts of arts integration in the university. Two extensive studies form the basis of our research. In the SPARC (Supporting Practice in the Arts, Research, and Curricula) interviews with academic leadership, faculty, and students at 38 universities, we asked about the impact of their arts-integration initiatives, including teaching, research, and community projects. In addition, a four-year survey-based longitudinal study explored ~4000 undergraduates' arts engagement at the University of Michigan. For more information about our research process, see pages 42-44; you can find notes on how the different types of sources are cited on page 40.

In addition to reports like this one, our insights into the impacts data are available as a graphic map (the images on the cover and on page 5 are excerpted from it). Each type of resource has a distinctive function. Readers can use the map for a broad overview of the impacts taxonomy, browsing for categories of impact that interest them; alternatively, the reports go deeper into the research, discussing some impacts in detail and providing specific examples of many types of impact. The map and reports are meant to ignite discussion, fuel research, and support clear communication. We encourage users to appropriate the taxonomy for advocacy and case-making, as a locator guide to identify where impacts can occur, and as a shared reference point and vocabulary for pursuing arts-integrative initiatives in the university. However, it is most exciting as a jumping-off point to further exploration.

https://www.a2ru.org/impacts/

# Arts-based Skills and Capacities for Students

University students are profoundly affected when they encounter the arts—whether the arts are happening in a studio, gallery, or theater, or integrated into their coursework, the faculty research they assist, or the campus environment. In addition to the inspiration and transformation inherent in the arts, students often find that their cognitive, personal, and social development is enriched. Even more, students stand to acquire a range of arts-related skills and capacities that can serve their endeavors in many arenas.

# A Jumping-off Point for Exploration

In our analysis of arts integration in the university, we organized categories of impact into a structure wherein the categories have relationships to each other. While that structure is more cyclical than linear, in narrating it here, we need an entry point—a beginning for the story. Our account of the impacts begins then with the convergence of two forces, or concepts: the arts and interdisciplinarity. These are the component parts of arts integration.

Several broad categories of impact that are pervasive and recurring—including *New Perspective, Awareness, and Understanding* and *Working Together*—emerge directly out of this arts-integrative situation. We also identified impacts on specific areas such as *Teaching, Research,* individual *Disciplines,* and of course, *Students*.

The impact of the arts and interdisciplinarity on students is tremendous. Not only are there the direct impacts on their learning and socio-cultural experience, there are also lingering impacts on their futures. Furthermore, students move through all the areas of academia, experiencing arts integration's impacts there indirectly. Because impacts on students are so many and varied, we present them in two separate reports.

This report explores the long list of skills and capacities that students build through their experiences with the arts. The presumption that these skills are transferable to other endeavors is threaded throughout the list, and "transference of skills" appears as its own, separately reported impact. Such a transference has a rippling effect, affecting student engagement with other fields and careers. That is, students bring the skills and capacities gained through the arts to, for example, medicine, business, and engineering.

Many arguments for arts integration hinge on these two impacts: the acquisition of arts-based skills, and the transfer of these skills to other domains. Therefore, this report includes a discussion of two of the most often-mentioned arts-based capacities—creativity and tolerance for ambiguity—on pages 26-31, as well as an analysis of the transfer of arts-based skills on pages 32-35.

A separate report details impacts on student learning, and practical impacts that prepare them for standardized tests and the professional world they encounter beyond the classroom. There, we also unpack far-reaching impacts on students' personal and social experience—on not only their own growth and development but also their connections to others.

Additional reports explore other impacts of arts integration, both broad and specific.

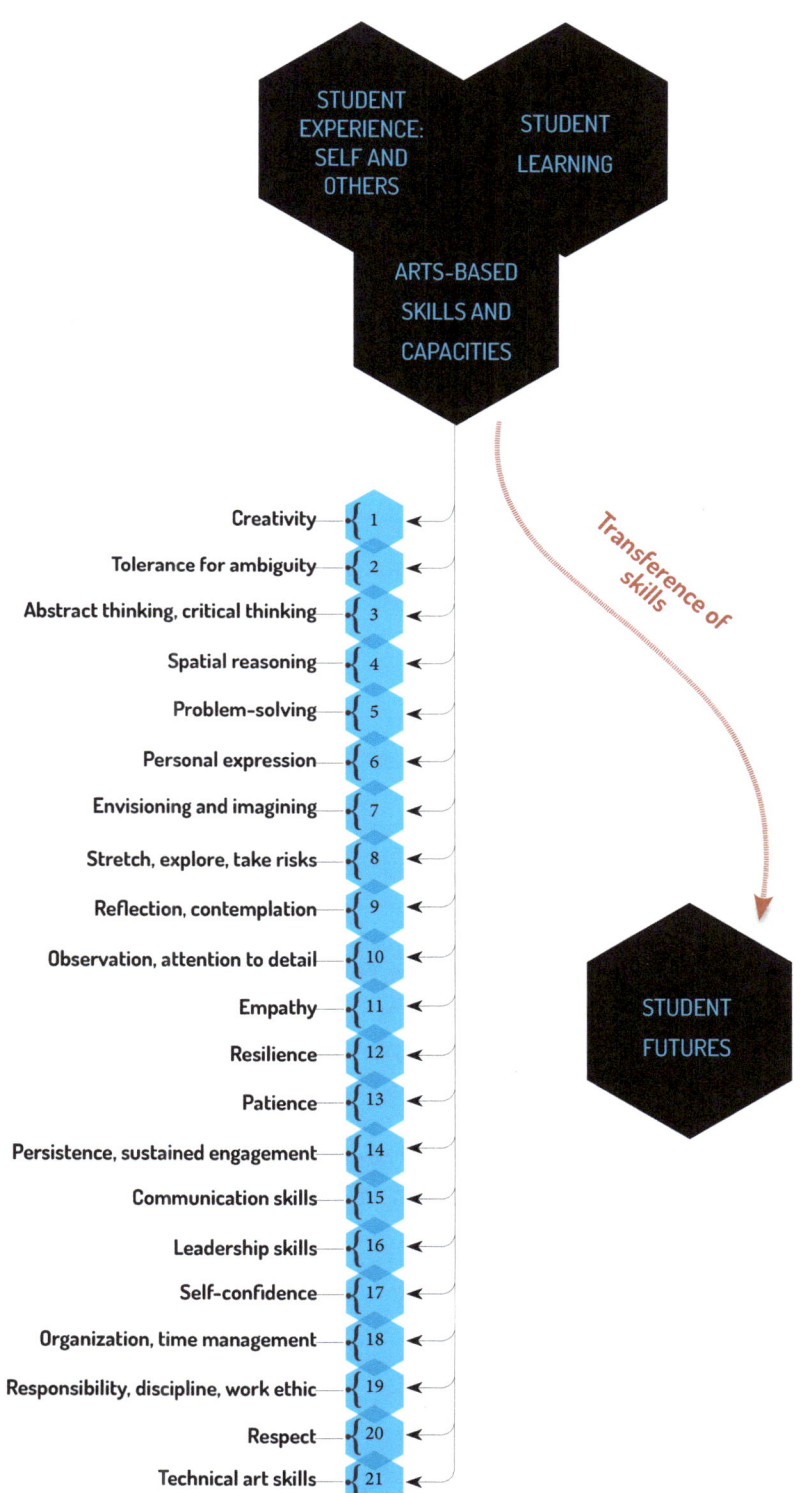

# Exploring Arts-based Skills and Capacities

This is a catalogue of those skills, capacities, and characteristics that an arts-integrative education imparts to students, according to our interviewees at research universities.

The items in this catalogue are numerous, and they represent a broad range of practices and habits of mind that benefit college students. As such, this list seems to characterize the arts as a magical force that sets students up with everything they need to succeed. In fact, any one of these impacts depends on situation and personality and a range of other factors, and furthermore, most of them lack experimental evidence.

But then, this "anecdotal evidence" points to something real in the student experience. The arts can indeed be a magical force, working in ways that all the examples on these pages point to, and in ways not addressed here. In the context of this report—focusing on the pragmatic concept of skills—it is easy to get caught up in an instrumental view of the arts. Yet the arts assert their intrinsic value, even in integrative settings—a reality that we do not intend to undermine with this report on those impacts that may ripple out. Potentially profound emotional, aesthetic, intellectual, spiritual, sensorial experiences remain at the center of encounters with the arts, regardless of any discussion of transferable skills.

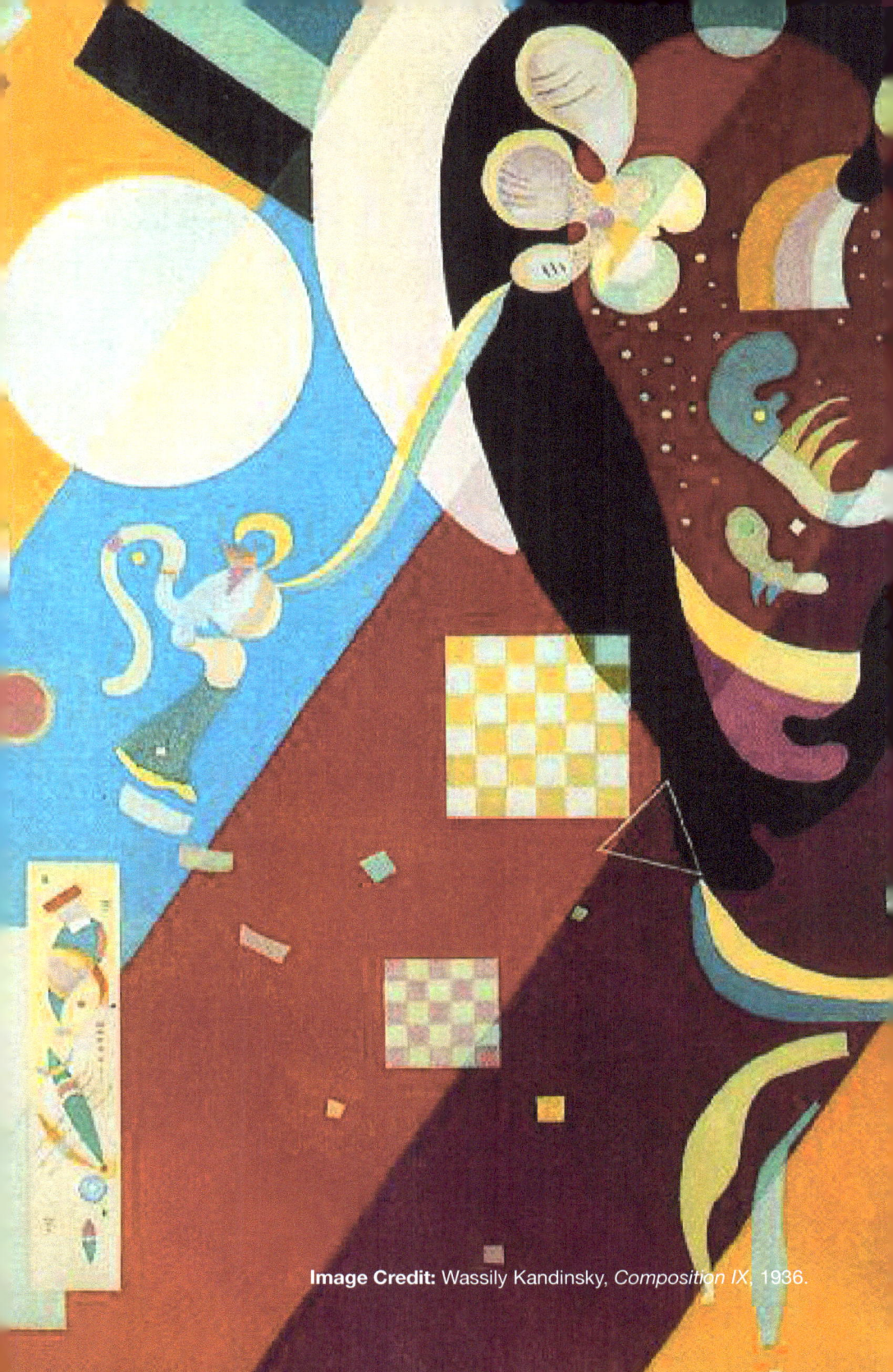

**Image Credit:** Wassily Kandinsky, *Composition IX*, 1936.

## CREATIVITY

(see discussion on creativity on pages 26-29)

"The projects have been really successful in the kind of experimentation and exploration that has gone on, and the progress that I've seen from their initial ideas to the final implementation." (Q25-2111-479)

"[Arts-integrative education] teaches a set of innovative thinking skills that are increasingly valued in a competitive workplace...arts-based skills put those people in really good standing for the kind of fresh thinking that they'll need to do." (Q25-2411-4113)

"...I get so sick of doing quantitative things all the time (for my major) it feels good to use the other side of my brain, and be able to be creative without the fear of messing up or being wrong." (UM-AE: In what ways do you think you can grow through the arts?)

## TOLERANCE FOR AMBIGUITY

(see discussion on tolerance for ambiguity on pages 30-31)

A physician in a university medical school notes that his trainees are all high achievers, used to having the right answer. He observes, however, that there are very few clear "right answers" in medical practice, and he includes live performance experiences as part of medical training precisely because they require a tolerance for ambiguity (Putting it into Practice).

A design studio course—co-listed between graduate business and theatre, speech, and dance—was offered in response to a national conversation about students' lack of flexible thinking skills. One of the course's instructors explains: "It's about mastering the SATs and finding a formula that gets you to the right answer…And this serves students well until they get to the university, and they find out actually we don't know if there is a right answer to a lot of these things … let alone what the right answer is when you start talking about serious problems like global warming or sustainability, or a lot of the things we're facing as a society today." Students remarked that the design studio changed their perspective on what they could and couldn't do and encouraged them to take risks, a mindset that de-prioritizes the need to be right (Shearin 2013).

## ABSTRACT THINKING

Alumni with a BA in Art History succeed at medicine, law, and finance, and "...that is not surprising to us at all, because there is that form of abstract thinking that they get trained in, which goes together with manipulation of data." (Q25-1302-7083)

One study found that dancers scored higher than non-dancers on a creativity test that assessed "abstractness of title." This test measured the subject's ability to create a title for a drawing that captured the essence or general feeling of that drawing. Higher scores were given for titles that go beyond simply naming the object in a drawing; for example, imaginative titles like "the time of your life" scored higher than simply descriptive titles like "happy boy" (Minton 2003).

## SPATIAL REASONING

Engineering students improve their spatial reasoning skills in an art class. (Q25-2411-4113)

Meta-analyses of published and unpublished studies examined the relationship between music and non-musical cognitive outcomes. Consistently, active musical instruction lasting even two years or less leads to dramatic improvements in spatial-temporal reasoning skills, as does listening to music (Hetland 2000a; Hetland 2000b).

## CRITICAL THINKING

"Those students that were more involved with the arts self-reported better critical thinking, better problem-solving, better oral and written skills…" (Q25-1805-6324)

"We are bombarded by visual images…If you have that arts training where you slow your thinking down, then you think about what is it that I am consuming, what is it that I am being bombarded with and how do I feel about it? How is it intending me to feel and do I agree with it and do I want to push back? So I think that's something that the study of the arts has to offer to everyone." (Q25-3604-8027)

One study used the California Critical Thinking Disposition Inventory to assess critical thinking in arts and non-arts undergraduates. Between discipline groups, there was no significant difference in overall score, but arts students scored significantly higher on several of the subscales: truth-seeking, maturity, open-mindedness. "These results suggest that learning in the arts builds strengths in several critical thinking dispositions and offers evidence that the arts do indeed enhance the disposition to think critically." The study attributes this to the inquiry-based nature of the arts (Lampert 2006, 215).

## PROBLEM-SOLVING

"Students in sculpture are constantly having their noses rubbed in the laws of nature and the laws of gravity. And when they get out, they have a lot of problem-solving skills that they apply elsewhere." (Q25-3614-8212)

"Social problems, community problems, health problems, conflicts, risks. Many of our students want to be part of a solution, and having the ability to think about some pretty significant macro-level ideas is an important tool...The arts can assist in imparting that tool." (Q25-2911-1531)

A group of professional researchers, lawyers, scientists, engineers, and business professionals who minored in Dance in college consistently noted how their current workplace practices draw on STEM-based as well as dance-based approaches to problem-solving (Payton, White, and Mullins 2017, 44).

Numerous studies on the educational and cognitive impacts of the arts and arts integration count improved problem-solving skills among the many benefits (for example, Dahlman 2007, 276; Duma and Silverstein 2014, 10; Ruppert 2006, 13).

## PERSONAL EXPRESSION

"Personal expression. The arts force you to reflect on yourself, what you've done in your life, how you feel about it, and what that means to you. I have yet to find another activity that forces you to do all of this like being in the Arts." (UM-AE: In what ways do you think you can grow through the arts?)

"It can get me to think outside the box, and to express myself. It seems like art is all about expression so it is a way to get out some stress and anger." (UM-AE: In what ways do you think you can grow through the arts?)

*Expression* is not so much the "free and undisciplined venting of emotion," but rather about a unique way of making meaning. Performing and visual arts have their own systems for meaning-making, and the sense of a work of art cannot be reduced to a verbal translation (Hetland et al. 2013, 66). The personal expression that students find through the arts involves the construction of new meaning-making systems.

## ENVISIONING AND IMAGING

In the visual arts, students "…think in images as they come up with an idea, as they progressively re-conceptualize their work, and as they imagine the steps to get there." (Hetland et al. 2013, 60). Students likewise think in sound, movement, and language as they create works of music, dance, and theatre.

One study finds that arts-based activities afford students ample opportunities to imagine new scenarios: "At the minute-to-minute level, this means that young people get lots of practice in developing future scenarios, explaining ideas, arguing for a particular tactic, and articulating strategies. They talk about 'what if?' 'what about?' 'could we try this?' 'let's try…' They throw out imaginative situations for others in the group to consider…" (Heath and Roach 1999, 25)

## STRETCH, EXPLORE, TAKE RISKS

"Artists always try new things and reach beyond what they have already done. They play, take risks, explore novel associations, and make mistakes, not deliberately, but routinely and inevitably…Artists Stretch and Explore by using the practice of conditional thinking: What if I try it this way, or this way, or that? They seek out the unusual, push beyond the limits of what is understood, and stride into the unknown as if they knew where they were going and what they were doing" (Hetland et al. 2013, 91).

"From the student perspective, I think what we've seen is a lot more willingness to explore, or awareness of, boundaries and specializations as we perceive them, and students being more interested in pushing at those or maybe trying to transcend those to some extent." (Q25-2914-1579)

## REFLECTION, CONTEMPLATION

"I feel being involved in the arts requires you to go within yourself to find what pleases you. It involved a level of introspection that most other subjects cannot lay claim to." (UM-AE: In what ways do you think you can grow through the arts?)

"Artists reflect metacognitively when they explicitly consider their works or what they are trying to do, why they used a particular technique or color or composition, what meanings they are trying to convey, and so on…Artists evaluate when they interpret and judge the aesthetic success of their own and others' works. Evaluation involves some kind of direct or implicit comparison of a work with other works or with envisioned criteria or goals, and it always involves considering quality." (Hetland et al. 2013, 81)

## OBSERVATION, ATTENTION TO DETAIL

Artists use the habit of observing all the time "…But observing goes beyond looking and means moving beyond habitual ways of seeing. Students need to learn to notice things that might otherwise be invisible and therefore unavailable as content for thinking." (Hetland et al. 2013, 73)

Medical students in an arts-based workshop engage in small-group exercises in (among other areas) mindful attention, description and interpretation (and noting the difference), and communication. These activities enhance learners' visual literacy and pattern recognition, which in turn hones their clinical competencies, including diagnostic acumen. (Childress and Love n.d.)

## EMPATHY

"It can expand your worldview and enable you to understand others' cultural perspectives. It breeds tolerance, acceptance, and understanding of differences. So, in that sense, it can act as a tool for social change." (UM-AE: In what ways do you think you can grow through the arts?)

"By participating in the arts one is able to see the world from viewpoints that you might not have thought of before. The arts just expand your worldview and help you connect better to those that see the world differently from you…" (UM-AE: In what ways do you think you can grow through the arts?)

Empathy is counted among the intrinsic benefits of the arts, that has private-to-public value: "The arts expand individuals' capacities for empathy by drawing them into the experiences of people vastly different from them and cultures vastly different from their own. These experiences give individuals new references that can make them more receptive to unfamiliar people, attitudes, and cultures." (McCarthy 2004, xvi).

# RESILIENCE

"[It gives students] resilience, because so much of what we do fails, and most of the other academic activities encourage safe success...It's short of perfection, short of completion of what could be done in that genre, and that's a really important learning lesson. We have employers who also ask graduates as a routine question now, 'Talk to me about a project of yours that failed, and what did you learn from it?' Some of our highest GPA students can't answer that question because they haven't risked failure." (Q25-2401-3928)

According to a study by the National Academies of Sciences, Engineering, and Mathematics (NASEM), "resilience" is among the many positive learning outcomes associated with the integration of the arts and humanities with science, technology, engineering, mathematics, and medicine (STEMM) curriculum. (Other outcomes identified in the study include written and oral communication skills, teamwork skills, ethical decision making, critical thinking and deeper learning, content mastery, general engagement and enjoyment of learning, empathy, and the ability to apply knowledge in real-world settings.) (National Academies 2018, 170)

## PATIENCE

"[The arts] helped me develop patience, creativity in my approaches to problems, ability to articulate ideas about aesthetic qualities, ability to be in conflict with a friend without it being destructive to our friendship, and a greater sense of my personal responsibility in group endeavors." (UM-AE: What role did the arts play in your development as a person, friend, colleague, and student during college?)

"Being involved in the arts teaches time management, patience, and discipline. These can all further a person's growth through life. (UM-AE: In what ways do you think you can grow through the arts?)

## PERSISTENCE, SUSTAINED ENGAGEMENT

In visual arts classes, students are taught to focus, to develop mental states conducive to working, and to self-regulate. They are pushed to stick with projects, and not to give up. They engage with their art: "Engagement is what makes someone want to persist. Personal engagement means that one gets pleasure out of the work itself rather than simply working at something for some future goal." (Hetland et al. 2013, 52)

## COMMUNICATION SKILLS

"It has to do with writing, which I do think is a form of creative expression. And I think that they learn, in my field in particular, but I'm sure in others too, how to be more audience-centered in the way that they write...And then I know of other students, who [succeed at] anything, from Divinity School to being a stockbroker, because it's all about being able to express your ideas and being persuasive." (Q25-5209-7948)

"That is part of what we try to do here, through our program, is to think about stories and to try to get students to understand: How do you tell a story in a compelling way? And how do you use media to help you tell a story?" (Q25-4410-4278)

"To give people the power to express themselves and to understand how others are expressing themselves increases communication." (Q25-2411-4113)

"Visual arts, graphic design, and architecture have immensely strengthened my communication skills - both verbal and visual." (UM-AE: What role did the arts play in your development as a person, friend, colleague, and student during college?)

## LEADERSHIP SKILLS

"Then there were all the leadership aspects—organizational skills, public speaking, involvement—all the kinds of things that you would expect to be part of skill-building around leadership, which are no different in the arts." (Q25-1805-6321)

Some college students experience the arts as a mechanism to develop personal skills; one cites specifically, "personal development, arts appreciation, leadership, personal knowledge," while another recounts growth "in leadership, in creativity, in expression, in communication." (UM-AE: In what ways do you think you can grow through the arts?)

## SELF-CONFIDENCE

Almost a third (30%) of college-age participants in a study that included a graphic design class in their science and social science curriculum mentioned "better self-confidence" as a benefit of the class (Dahlman 2007, 276).

Participants in the U-M study frequently cited increased confidence as part of their development affected by arts engagement. (UM-AE: What role did the arts play in your development as a person, friend, colleague, and student during college?)

## ORGANIZATION, TIME MANAGEMENT

"It [the arts] helped me become more organized and develop professionally. It also helped me get a better view on the world and appreciate what I have." (UM-AE: What role did the arts play in your development as a person, friend, colleague, and student during college?)

"The arts helped me grow as a person and a student. I developed much better time management skills as well as effective organization skills…" (UM-AE: What role did the arts play in your development as a person, friend, colleague, and student during college?)

"Helped me organize myself, think analytically, and develop leadership skills." (UM-AE: What role did the arts play in your development as a person, friend, colleague, and student during college?)

"The arts brought me closer to a diverse group of students as we worked toward a common goal. The intense hours of practice also helped me develop my time management skills" (UM-AE: What role did the arts play in your development as a person, friend, colleague, and student during college?)

## RESPONSIBILITY, DISCIPLINE, WORK ETHIC

"[The arts] can help build relationships and character. It can teach discipline and responsibility, etc." (UM-AE: In what ways do you think you can grow through the arts?)

Among the impacts of a program that engages high school students with the plays of William Shakespeare are "responsibility to take risks and support others in taking risks…responsibility to approach the work and their colleagues with a spirit of generosity…and responsibility to the work and the group" (Seidel 1999, 88).

"…I also think participation in the arts requires a lot of hard work and stamina, so you grow in those ways as well." (UM-AE: In what ways do you think you can grow through the arts?)

## RESPECT

"[The arts] taught me discipline, respect, and opened my mind…" (UM-AE: What role did the arts play in your development as a person, friend, colleague, and student during college?)

"[Through the arts,] you can become more open-minded and respectful of others while gaining your own set of morals and beliefs through self-expression." (UM-AE: In what ways do you think you can grow through the arts?)

# TECHNICAL ART SKILLS

"Students develop the disposition to use skill attentively in various media and tools, and with conventions…Students develop a sense of what they can and cannot do with different tools and materials, and they become more adept at choosing the right tools and materials for the piece they wish to make. As students develop technique, they also learn about the elements of artworks, such as form, line, surface, value, and how to employ artistic conventions such as perspective or color mixing." (Hetland et al. 2013, 41)

"…it helped me with time management skills because dance practices take a large chunk of time, but it also developed me artistically and gave me another chance to develop my dance skills." (UM-AE: What role did the arts play in your development as a person, friend, colleague, and student during college?)

"I have begun arranging music, developed an interest in photography, and took a print-making class – none of which I did before college." (UM-AE: What role did the arts play in your development as a person, friend, colleague, and student during college?)

# TRANSFERENCE OF SKILLS

(see discussion on transference of skills on pages 32-35)

"What we're going to teach them here is skills that they can transfer to anything or keep in music, either way." (Q25-3106-6257)

"I see a lot of students in that situation where they're using skills that they've cultivated within the art context and then kind of transferring them to the other context." (Q25-3613-8194

# Discussion: Creativity, Tolerance for Ambiguity, and Transference of Skills

In general, our ontology does not claim to establish either causality or explanation for the impacts cited; it is simply a record of impacts reported in the SPARC interviews, the University of Michigan Arts Engagement surveys, and, to some extent, the literature. However, because the reported cognitive impacts of the arts on students are of particular interest to users of the ontology, we attempt to unpack them a bit here.

We examine closely two attributes that are often credited to the study and practice of the arts: creativity, and tolerance for ambiguity. For each, we offer an expanded definition as well as a summary of the evidence for the arts' impact on it. Then, we consider the matter of transfer; are creativity and tolerance for ambiguity heightened only within arts experiences, or elsewhere in a student's life as well? We expect that this discussion will add depth to the broad range of impacts described in this report, enabling more purposeful arts integration and better-informed advocacy.

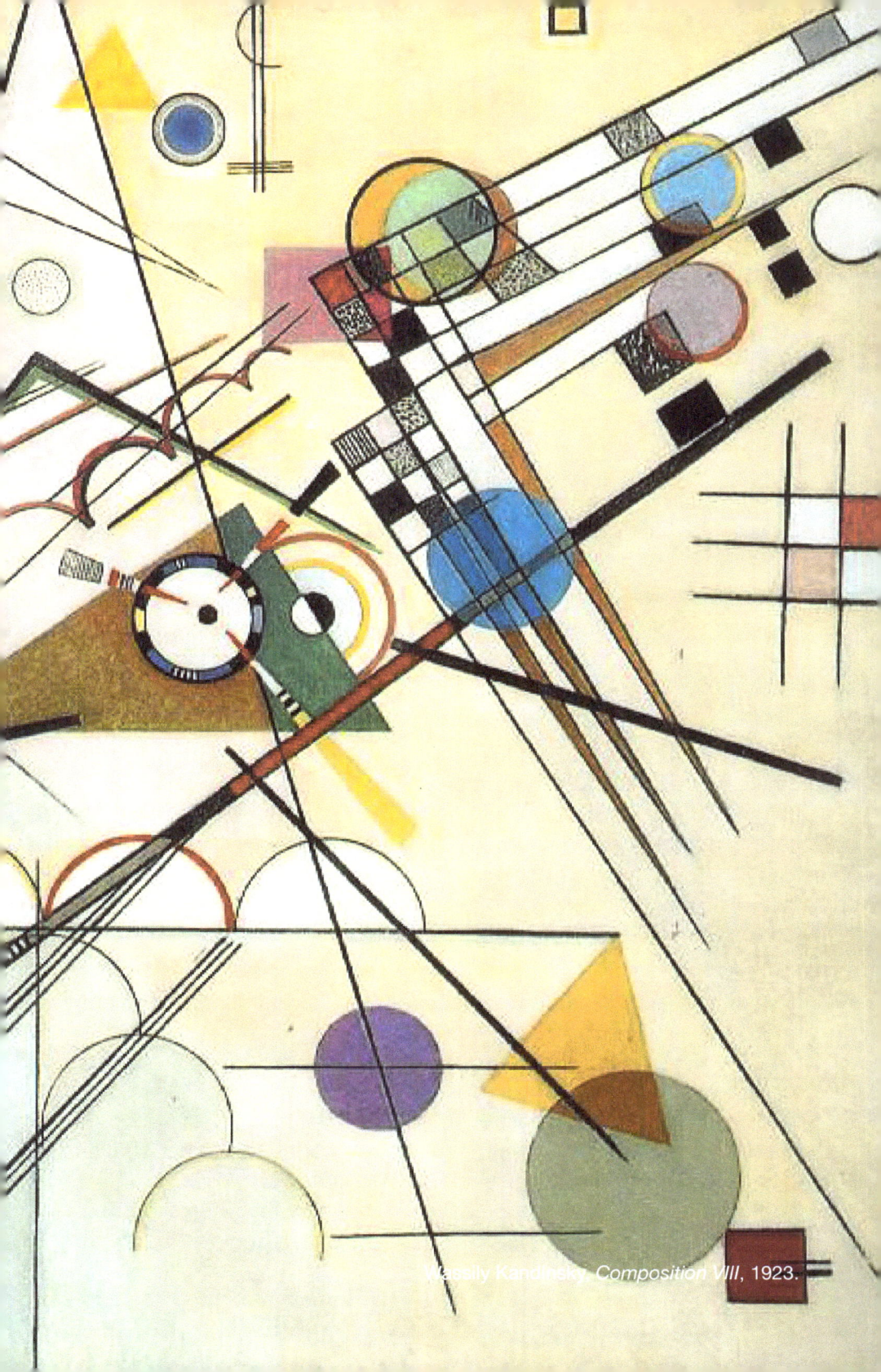
Wassily Kandinsky, *Composition VIII*, 1923.

# CREATIVITY

Creativity—sometimes branded as "innovation" and often seemingly equated with the generation of novel ideas—is widely valued, in professional fields from medicine to business to engineering and beyond (Lichtenberg, Woock, and Wright 2008; "Engineering and the Arts Collaboration" n.d.; Shearin 2013; Styhre and Eriksson 2008; Broeck, Cools, and Maenhout 2008, for example). Creativity is positioned as the quality that will distinguish job candidates from their competitors—including robotic ones—and will drive global economic success. Artists often represent paragons of creativity, when in fact they are examples of a particular type of creativity; there are creative people in every field.

A complete account of creativity—including its sources, markers, and neurology—is beyond the scope of this paper. We aim here to establish a common baseline understanding to inform discussion of creativity as an impact of arts integration.

The NEA's summary of creative thinking comprises memory, divergent thinking (the ability to generate possible solutions), and convergent thinking (the ability to think strategically, to apply logic and discretion to narrow a quantity of ideas to the best ones) (National Endowment for the Arts 2015, 20). As researchers continue to model creativity, some also acknowledge intelligence and personality as control variables (Agnoli, Corazza, and Runco 2016, 172).

In addition, researchers have associated a dizzying number of mental capacities with creativity. The Torrance Tests of Creative Thinking (TTCT)—developed and refined since 1966 but not unproblematic—tests for fluency, or the number of relevant ideas; originality, or the number of statistically infrequent ideas: elaboration, or the number of added ideas; abstractness of titles (for pictures); and resistance to premature closure, or the degree of psychological openness (Kim, Kyung Hee 2006, 5). Additional studies of highly creative adults show that they share these traits: flexibility, fluency, elaboration, tolerance of ambiguity, originality,

breadth of interest, sensitivity, curiosity, independence, reflection, action, concentration and persistence, commitment, expression of total personality, and sense of humor (Guilford 1973, 2-3).

It is also useful to think of creativity not just as a quality, but as an activity or process. The creative process is often described in not-necessarily-linear phases, as periods of taking in (including openness or preparation), "back burner" (withdrawal from the problem, incubation), insight or illumination, hard work (discipline, concentrated effort, elaboration), and evaluation (closure, verification) (Csikszentmihaly 1996, 79-80; Guilford 1973, 1). The creative process may require suppressing the editing, inhibiting parts of our brain (Limb and Braun 2008, e1679) and achieving a "flow" state (Csikszentmihaly 1996, 110-123).

Finally, any attempt to define creativity must situate the individual within a context; we don't deem someone creative in a vacuum, but rather relative to a domain and a culture (Baer 2017; Csikszentmihalyi 1996, 28; Runco and Beghetto 2018, 4). When we list "creativity" among the student skills and capacities that arts integration impacts, we are often referring to the aspects of creativity that lie with an individual; however, following a more global, systems-oriented definition, culture, the community, and individual disciplines also affect our perception of creativity.

Whether we employ the NEA's relatively simple recipe for creativity— divergent thinking plus convergent thinking plus memory—or account for all the nuance and perspective that complicate that recipe, the implication for arts integration in the university remains the same: creativity is more than just the generation of novel ideas. If it is actually this multi-dimensional attribute we value and hope to cultivate in students, then we must acknowledge its complexity; the arts can't impart creativity in a single encounter.

# EVIDENCE OF ARTS IMPACT ON CREATIVITY

There is abundant literature theorizing and describing how the arts are correlated with creativity, but many interested educators seek evidence of causality as well as correlation. While there continue to be case studies and theorizing that associate the arts with creativity—and we should not dismiss qualitative accounts in a positivistic quest for only a certain type of evidence—there are also controlled experimental studies as well. What follows is a sampling of findings that show a causal relationship between study of the arts and creativity. Necessarily, each one situates its results within a particular artistic discipline and a specific dimension of creativity; nonetheless, they represent a mounting body of evidence that arts experiences increase creativity.

As a small sample, these studies offer a dual reminder—that the arts are not a monolith, and that creativity is multi-dimensional, involving personality characteristics of the individual, a loosely defined process, and a range of cognitive capacities. In this sample, we see a focus on the performing arts, and more specifically, on "creative" dance and drama that require students to generate ideas within a form. Likewise, we see results specifically in the area of divergent thinking, of coming up with those new ideas. While these are promising results, especially for those eager to see students "innovate," they only begin to address the expansive arena that is creativity. Additional research needs to investigate relationships between other art forms and other aspects of creativity.

## SAMPLE STUDIES

1.      Two studies, using the TTCT and other quantitative and qualitative measures, demonstrate that dance experience leads to increased creativity. More specifically, subjects scored higher on the fluency, originality, and abstractness of titles measures on the TTCT (Kim, Juja 1998, 107; Minton 2003, 40). In one of these studies, "creative dance"—that which requires a measure of problem-solving—led to significant gains in creativity while traditional dance did not (Kim, Juja 1998, 107).

2.      Recall that one component of creativity is "divergent thinking," which involves thinking in multiple directions, seeking changes, and investigating. Some taxonomies identify individual elements of divergent thinking such as fluency (the quantity of unconventional and associated ideas generated on a topic) and flexibility (number of associations generated that relate to different fields). In one study, postgraduate students scored higher on both those aspects of divergent thinking after a ten-week creative drama course (Karakelle 2009, 127).

3.      Another study used behavioral, fMRI, and DNA testing to determine if there were differences between performing arts and non-performing arts students. Most notably, they found key neural differences between the two groups that, considered in light of the behavioral tests measuring divergent thinking, indicate that the performing arts students are better at the generation of novel ideas (Dunbar 2008, 90).

## TOLERANCE FOR AMBIGUITY

Increased tolerance for ambiguity is one of the impacts attributed to arts integration, and in fact it is often linked with creativity and problem-solving (Brophy 1998; O'Connor, Becker, and Bell 2017; Stoycheva 2003; Zenasni, Besançon, and Lubart 2008). However, there has been less sustained scholarly attention to ambiguity tolerance than to creativity, and hence, less evidence for the impact of the arts on it. Nonetheless, we give it particular attention here because of the promise it seems to hold as an important capacity for those facing the complicated problems of the 21st century.

Ambiguous stimuli is that which is perceived as unfamiliar, unclear, having multiple incompatible interpretations, and most commonly, offering inadequate information to be clearly understood (McLain 1993, 184). Ambiguity tolerance refers to the way people perceive or process ambiguity when confronted with it. The person with low tolerance for ambiguity experiences stress, reacts prematurely, and avoids ambiguous situations. A person with high tolerance for ambiguity, however, perceives ambiguous situations as desirable, challenging, and interesting (Furnham and Ribchester 1995, 179). An alternative description of the brain's response to ambiguity states, "True ambiguity results when no single solution is more likely than other solutions...Each interpretation therefore is as valid as the other interpretations, and there is no correct interpretation" (Zeki 2004, 175). In this view, the capacity to hold multiple interpretations is not a separate mental faculty specific to the arts; it is a general capacity of the brain that has an important role in the acquisition of knowledge (Ibid., 190).

Many disciplines, as well as professions like medicine and law, are rife with contradictions and lack of clarity—in short, ambiguity. However, typical of many faculty, one professor of business administration notes that students at his institution are less and less tolerant of ambiguity, and more concerned with finding the one right answer to a problem (Shearin 2013). Such students might benefit from a curriculum that acknowledges ambiguity as commonplace; indeed, "Tolerance for ambiguity resembles or seems related to a cluster of traits and abilities that are desirable in college-level learning" (Tatzel 1980, 377).

People who are comfortable with uncertainty and the lack of a single right answer can thrive in real-world ambiguous situations, and can hold a space for unconventional answers as well as the views of others (Giguere 2014). Ambiguity tolerance may encourage divergent thinking because it is negatively correlated with dogmatism and the need for clarity, and positively correlated with ideation and innovation (Brophy 1998, 132). Furthermore, a tolerance for ambiguity is a natural fit with creative problem-solving because solutions often evolve through successive ideations (Ibid.), a process that requires the ability to persevere even while there is no right answer in sight.

There is some evidence establishing a causal link between arts integration and an increased tolerance for ambiguity. One study found that students entering college in the Arts scored significantly higher in tolerance for ambiguity than Business students, "a finding which supports the linkage of tolerance for ambiguity with creativity and mental flexibility" (Tatzel 1980, 378). In another study, medical students participated in a pedagogic approach called Visual Thinking Strategies (VTS) which asks students to discuss art works and discuss their different possible meanings. Based on student surveys, researchers conclude, "Art may contribute especially to the development of medical students' tolerance of ambiguity, also related to the enhancement of empathy" (Bentwich and Gilbey 2017, 1). (See pages 34 and 35 for a closer look at arts integration into medical training.)

These findings speak to a correlation between the arts and ambiguity tolerance, but not necessarily a causal relationship—that is, perhaps students in the first study chose to major in the Arts because they were already tolerant of ambiguity. However, like the National Academies of Sciences, Engineering, and Medicine (NASEM), we acknowledge how difficult it is to carry out causal studies on educational interventions, and how few such studies there are. Although the current evidence base is limited, we find the links between the arts and tolerance for ambiguity promising enough to recommend the pursuit of arts integrative approaches, as does NASEM (National Academies 2018, 4).

## TRANSFER

Assumed in much of the SPARC data on impacts of arts integration is the idea that skills gained through the arts will transfer to other domains, that a student who works creatively in an art class will also mobilize that creativity in engineering or business. Therefore, the issue of transfer is of considerable importance.

While there is literature on arts education transfer that examines specific instrumental claims—for example, that the arts will improve academic performance in non-arts areas like reading and math—only a very few of these claims have been proven (Hetland and Winner 2004; Winner and Cooper 2000, 11). More salient for our purposes is the question of whether higher order thinking skills transfer; that is the type of "transfer" we explore here.

It appears that higher order thinking skills can be applied in different domains. Indeed, there is evidence that cognitive skills such as problem-solving, inventive thinking, and decision-making operate across domains, and that, when faced with novel situations, people routinely try to apply knowledge, skills, and specific strategies from other, more familiar situations (Perkins and Salomon 1989, 22). We envision a similar process wherein students mobilize the habits of mind learned through the arts in fields like medicine or engineering.

We consider "transfer" to be less a unidirectional projection from the arts to some other domain, and more a complex system in which arts learning is entangled or entwined with other learning (Catterall 2002, 156-157). Restated, "…learning in the arts and in other subjects each contribute in their distinctive ways to a constellation of higher order cognitive capacities and dispositions—or ways of thinking—by activating them within broad and flexible pedagogical contexts" (Burton, Horowitz, and Abeles 2000, 253-254).

Arts integration entails just such activation, and this intellectual entanglement is evident in a six-year qualitative study of science and social science college students who took a graphic design class. Students' written responses indicate that artistic experience in class

helped them develop problem-solving skills, and see the environment in new ways. The focus on drawing is deemed especially effective because it requires students to connect seemingly incompatible categories of experience (Dahlman 2007, 275), a habit of mind that serves in science and social science as well as in art. Across several (K-12) schools that have adopted an arts-integrated curriculum, teachers and school leaders believed that arts integration encouraged students to give more thoughtful and thought-provoking responses to questions rather than quick answers, helped students to better articulate and justify their opinions, and increased students' ability to approach ideas from multiple perspectives (Duma and Silverstein 2014, 10). While there are many other factors at work in these schools that more rigorous studies would control for, these reports indicate that indeed arts-related habits of mind seem to transfer beyond the walls of the studio.

Transfer depends somewhat on how students acquire knowledge initially; if instruction is tailored, the potential for transference increases. Instruction that incorporates meaningful tasks, teacher modeling through thinking-aloud, multiple opportunities for students to practice the desired thinking skills, teacher coaching and feedback, and student reflection all promote transference. Especially important for "far" transfer (to situations that are dissimilar to the one where the skill was learned), desired thinking skills should be explicitly taught during domain-specific instruction (Tiruneh et al 2018, 10). That is, in a class dedicated to the arts, instructors could articulate the thinking skills being used and note explicitly how they are applied.

However, some traditional college-age students demonstrate the ability to integrate their learning independently, without tailored instruction. They connect similar ideas that themselves remain distinctive, apply knowledge from one context to another, and create new knowledge by combining insights. One researcher working with this age-group concludes that students' experiences are related and fluid, and it is in fact the students who are integrating learning, unaided by instructors (Barber 2012, 608). If this is so, then college students might apply cognitive skills acquired through the arts in other contexts, without tailored instruction.

## TRANSFER: EXAMPLES FROM MEDICAL TRAINING

We can turn to the field of medical education to find a strong case for the intertwining of cognitive skills in college-age students. Several medical schools use arts experiences to bolster these skills in their students, with ample evidence that this is an effective approach.

There is some concern that young doctors are not being trained in the important skill of "inspection"—careful observation for the purposes of clinical diagnosis—but rather learning to rely on expensive high-tech testing. To address this need, several medical schools use a version of Visual Thinking Strategies (VTS), a pedagogic approach involving discussion of art works and their possible meaning. Typically, students participate in guided sessions looking at and analyzing works of art. For example, in one program, medical students spend three 90-minute sessions with museum educators and then respond to both art and patient images. After participating in this program, students significantly increased the amount of time spent looking at patient images, the number of words used to describe them, and the number of observations about the images (Klugman, Peel, Beckmann-Mendez 2011). Other medical schools that incorporate a VTS approach into their curriculum report that students make more accurate visual observations (Naghshineh et al. 2008, 995), have richer descriptions and propose more explanations for what they see (Pellico, Friedlaender, and Fennie 2009, 648), communicate more effectively (Slota et al. 2017, 1), and use more speculative thinking, marked by words like "suggest," "might," and "seems." These words imply the possibility of multiple interpretations of observations, and thus the likelihood of constructing a more in-depth explanation (Jasani and Saks 2013, e1329).

In addition to improvements in observation skills, VTS and arts-based strategies for medical students have resulted in improvements in listening, explaining, empathizing, cross-cultural understanding, reflecting, and working collaboratively (Bentwich and Gilbey 2017; Childress and Love n.d.; Gottlieb et al. 2018; Lyon et al. 2018; Slota et al. 2017).

The success of such arts-based pedagogies used in medical training rests on transfer—the ability of medical students to apply the habits of mind acquired in looking at art to patient scenarios.

Notably, many of the medical programs that incorporate the arts into their training specifically cite tolerance for ambiguity as a capacity that they want to build in their students, and that the arts is particularly effective at addressing ("About the Medical Arts" n.d.; Bentwich and Gilbey 2017; Childress and Love n.d.; Klugman, Peel, Beckmann-Mendez 2011; Weinstein 2011). Dr. Joel Howell has made attendance at live performance an integral part of training in The Medical Arts Program at University of Michigan Medical School, partly because of the tolerance for ambiguity that it promotes. He observes, "[Doctors are] constantly not sure what to do. And there's two ways you can deal with this ambiguity if you're a trainee. You can freak out; you can say, 'I want to know the right answer.' Or you can revel in it" ("Putting it into Practice" n.d.). He sees confrontation with the multiple possible interpretations of a music, theater, or dance performance as an excellent way to train tolerance for ambiguity in his students. He also turns to visual art because of the way it traffics in ambiguity, empathy, complexity, and death—all important issues for young medical professionals ("Art and Medicine" n.d.).

The medical schools that integrate visual arts and performance into their curriculum provide practical evidence for the value and utility of arts-inspired meta-cognitive skills, as well as their transfer to non-arts settings. That is, these medical schools incorporate the arts because they have found them to be effective; their students become better doctors because of their experiences in the arts. This does not allow us to make claims about all the arts, all the meta-cognitive skills, or all the professions. It does, however, establish a practical use-case, the basis of which indicates that arts integration in the university may also have powerful benefits for future engineers, CEO's, scientists, and lawyers.

# REFERENCES

"About the Medical Arts Program." n.d. The Medical Arts Program at University of Michigan Medical School. http://themedicalarts.med.umich.edu/about.html.

Agnoli, Sergio, Giovanni E. Corazza, and Mark A. Runco. 2016. "Estimating Creativity with a Multiple-Measurement Approach Within Scientific and Artistic Domains." *Creativity Research Journal* 28 (2): 171–76. https://doi.org/10.1080/10400419.2016.1162475.

"Art and Medicine." n.d. University of Michigan Museum of Art. Accessed August 14, 2018. http://www.umma.umich.edu/news/art-and-medicine.

Baer, John. 2017. "The Devil Is in the Details: Why the Answer to Most Questions About Creativity Will Always Be 'It Depends.'" *The Journal of Creative Behavior* 51 (4): 297–300. https://doi.org/10.1002/jocb.188.

Barber, James P. 2012. "Integration of Learning: A Grounded Theory Analysis of College Students' Learning." *American Educational Research Journal* 49 (3): 590–617. http://www.jstor.org/stable/23249239.

Bentwich, Miriam Ethel, and Peter Gilbey. 2017. "More than Visual Literacy: Art and the Enhancement of Tolerance for Ambiguity and Empathy." *BMC Medical Education* 17 (November). https://doi.org/10.1186/s12909-017-1028-7.

Broeck, Herman van den, Eva Cools, and Tine Maenhout. 2008. "A Case Study of Arteconomy - Building a Bridge between Art and Enterprise: Belgian Businesses Stimulate Creativity and Innovation through Art." *Journal of Management and Organization* 14 (5): 573–87.

Brophy, Dennis R. 1998. "Understanding, Measuring, and Enhancing Individual Creative Problem-Solving Efforts." *Creativity Research Journal* 11 (2): 123–50. https://doi.org/10.1207/s15326934crj1102_4.

Burton, Judith M., Robert Horowitz, and Hal Abeles. 2000. "Learning in and Through the Arts: The Question of Transfer." *Studies in Art Education* 41 (3): 228–57. https://doi.org/10.2307/1320379.

Catterall, James S. 2002. "The Arts and the Transfer of Learning." In *Critical Links: Learning in the Arts and Student Academic and Social Development*, edited by R.J. Deasy, 151-157. Washington: Arts Education Partnership.

Childress, Marcia Day, and M. Jordan Love. n.d. "Clinician's Eye." University of Virginia School of Medicine. Accessed July 10, 2018. https://med.virginia.edu/biomedical-ethics/clinicians-eye/.

Csikszentmihalyi, Mihaly. 1996. *Creativity: Flow and the Psychology of Discovery and Invention*. 1st ed. New York: HarperCollinsPublishers.

Dahlman, Ylva. 2007. "Towards a Theory That Links Experience in the Arts with the Acquisition of Knowledge." *International Journal of Art & Design Education* 26 (3): 274–84.

Duma, Amy, and Lynne Silverstein. 2014. "A View into a Decade of Arts Integration." *Journal for Learning through the Arts* 10 (1). https://escholarship.org/uc/item/3pt13398#page-4.

# REFERENCES

Dunbar, Kevin Niall. 2008. "Arts Education, the Brain, and Language." In *Learning, Arts, and the Brain: The Dana Consortium Report on Arts and Cognition*, edited by Carolyn H. Asbury and Barbara Rich, 81-92. New York: Dana Press. http://dana.org/Publications/PublicationDetails.aspx?id=44422.

"Engineering and the Arts Collaboration." n.d. College of Engineering, The University of Iowa. Accessed June 19, 2018. https://www.engineering.uiowa.edu/future-students/undergraduate/engineering-and-arts-collaboration.

Furnham, Adrian, and Tracy Ribchester. 1995. "Tolerance of Ambiguity: A Review of the Concept, Its Measurement and Applications." *Current Psychology* 14 (3): 179–99. https://doi.org/10.1007/BF02686907.

Giguere, Miriam. 2014. Tolerating Ambiguity -- Being OK with Not Knowing! TEDxSoleburySchool. https://www.youtube.com/watch?v=RZ0tS2vBEIA.

Gottlieb, Susan, Leona Jaglom, Ilya Bialik, Steven Gelman, Yvonne Ferreira, Revathy Sundaram, Madhu Gudavalli, Ali Nadroo, Jolanta Kulpa, and Pramod Narula. 2018. "A Humanities Curriculum in a Pediatric Training Program." *Academic Pediatrics* 18 (5): e25–26. https://doi.org/10.1016/j.acap.2018.04.073.

Guilford, J. P. 1973. "Characteristics of Creativity." https://eric.ed.gov/?id=ED080171.

Heath, Shirley Brice and Adelma Roach. 1999. "Imaginative Actuality: Learning in the Arts during the Nonschool Hours." In *Champions of Change: The Impacts of the Arts on Learning*, edited by Edward B. Fiske, 19-34. Washington, D.C.: Arts Education Partnership.

Hetland, Lois. 2000a. "Learning to Make Music Enhances Spatial Reasoning." *Journal of Aesthetic Education* 34 (3/4): 179–238. https://doi.org/10.2307/3333643.

Hetland, Lois. 2000b. "Listening to Music Enhances Spatial-Temporal Reasoning: Evidence for the 'Mozart Effect.'" *Journal of Aesthetic Education* 34 (3/4): 105–48. https://doi.org/10.2307/3333640.

Hetland, Lois and Ellen Winner. 2004. "Cognitive Transfer From Arts Education to Nonarts Outcomes: Research Evidence and Policy Implications." In *Handbook of Research and Policy in Art Education*, edited by E. Eisner and M. Day, 135-162. Mahwah, NJ: National Art Education Association, accessed June 12, 2018, https://www.taylorfrancis.com/books/e/9781135612313/chapters/10.4324%2F9781410609939-13

Hetland, Lois, Ellen Winner, Shirley Veenema, and Kimberly M. Sheridan. 2013. *Studio Thinking 2: The Real Benefits of Visual Arts Education*. Second. New York: Teachers College Press.

Jasani, Sona K., and Norma S. Saks. 2013. "Utilizing Visual Art to Enhance the Clinical Observation Skills of Medical Students." *Medical Teacher* 35 (7): e1327–31. https://doi.org/10.3109/0142159X.2013.770131.

Karakelle, Sema. 2009. "Enhancing Fluent and Flexible Thinking through the Creative Drama Process." *Thinking Skills and Creativity* 4 (2): 124–29. https://doi.org/10.1016/j.tsc.2009.05.002.

# REFERENCES

Kim, Juja. 1998. "The Effects of Creative Dance Instruction on Creative and Critical Thinking of 7th Grade Female Students in Seoul, Korea." New York: New York University. http://www.artsedsearch.org/study/the-effects-of-creative-dance-instruction-on-creative-and-critical-thinking-of-7th-grade-female-students-in-seoul-korea/.

Kim, Kyung Hee. 2006. "Can We Trust Creativity Tests? A Review of the Torrance Tests of Creative Thinking (TTCT)." *Creativity Research Journal* 18 (1): 3–14. https://doi.org/10.1207/s15326934crj1801_2.

Klugman, Craig M., Jennifer Peel, and Diana Beckmann-Mendez. 2011. "Art Rounds: Teaching Interprofessional Students Visual Thinking Strategies at One School." *Academic Medicine: Journal of the Association of American Medical Colleges* 86 (10): 1266–71. https://doi.org/10.1097/ACM.0b013e31822c1427.

Lampert, Nancy. 2006. "Critical Thinking Dispositions as an Outcome of Art Education." *Studies in Art Education* 47 (3): 215–28. https://doi.org/10.1080/00393541.2006.11650083.

Lichtenberg, James, Christopher Woock, and Wright, Mary. 2008. "Ready to Innovate." R-1424-09-RR. New York: The Conference Board. https://www.americansforthearts.org/by-program/reports-and-data/legislation-policy/naappd/ready-to-innovate.

Limb, Charles J., and Allen R. Braun. 2008. "Neural Substrates of Spontaneous Musical Performance: An FMRI Study of Jazz Improvisation." *PLOS ONE* 3 (2): e1679. https://doi.org/10.1371/journal.pone.0001679.

Lyon, Philippa, Patrick Letschka, Tom Ainsworth, and Inam Haq. 2018. "Drawing Pedagogies in Higher Education: The Learning Impact of a Collaborative Cross-Disciplinary Drawing Course." *International Journal of Art & Design Education* 37 (2): 221–32. https://doi.org/10.1111/jade.12106.

McCarthy, Kevin F., ed. 2004. *Gifts of the Muse: Reframing the Debate about the Benefits of the Arts*. Santa Monica, CA: RAND Research in the Arts.

McLain, David L. 1993. "The Mstat-I: A New Measure of an Individual's Tolerance for Ambiguity." *Educational and Psychological Measurement* 53 (1): 183–89. https://doi.org/10.1177/0013164493053001020.

Minton, Sandra. 2003. "Assessment of High School Students' Creative Thinking Skills: A Comparison of Dance and Nondance Classes." *Research in Dance Education* 4 (1): 31–49. https://doi.org/10.1080/14647890308307.

Naghshineh, Sheila, Janet P. Hafler, Alexa R. Miller, Maria A. Blanco, Stuart R. Lipsitz, Rachel P. Dubroff, Shahram Khoshbin, and Joel T. Katz. 2008. "Formal Art Observation Training Improves Medical Students' Visual Diagnostic Skills." *Journal of General Internal Medicine* 23 (7): 991–97. https://doi.org/10.1007/s11606-008-0667-0.

National Academies of Sciences, Engineering. 2018. *The Integration of the Humanities and Arts with Sciences, Engineering, and Medicine in Higher Education: Branches from the Same Tree*. Washington, D.C.: The National Academies Press. https://doi.org/10.17226/24988.

# REFERENCES

National Endowment for the Arts. 2015. "How Creativity Works in the Brain." Washington, D.C.: Santa Fe Institute Working Group. https://www.arts.gov/publications/how-creativity-works-brain.

O'Connor, Peter J., Karen Becker, and Sarah Bell. 2017. "Embracing Ambiguity in the Workplace: A New Measure of Tolerance of Ambiguity." Report. Brisbane: Queensland University of Technology. https://eprints.qut.edu.au/108255/.

Payton, Fay Cobb, Ashley White, and Tara Mullins. 2017. "STEM Majors, Art Thinkers (STEM + Arts) – Issues of Duality, Rigor and Inclusion." *Journal of STEM Education : Innovations and Research* 18 (3): 39–47.

Pellico, Linda Honan, Linda Friedlaender, and Kristopher P. Fennie. 2009. "Looking Is Not Seeing: Using Art to Improve Observational Skills." *Journal of Nursing Education* 48 (11): 648–53. http://search.proquest.com/docview/203951458/abstract/8835AA7D43B46C3PQ/1.

Perkins, D.N., and Gavriel Salomon. 1989. "Are Cognitive Skills Context-Bound?" *Educational Researcher* 18 (1): 16–25. https://doi.org/10.3102/0013189X018001016.

"Putting It Into Practice: Integrating UMS Performances into Science and Medicine Classrooms." n.d. University Musical Society. Accessed March 24, 2019. https://3puuzj4cgp0w1zze71361rza-wpengine.netdna-ssl.com/wp-content/uploads/2016/02/0043-0345-science-and-medicine-f-171018.pdf.

Runco, Mark A, and Ronald A Beghetto. 2018. "Primary and Secondary Creativity." *Current Opinion in Behavioral Sciences* 27, 4.

Ruppert, Sandra. 2006. *Critical Evidence: How the ARTS Benefit Student Achievement*. Washington, D.C.: National Assembly of State Arts Agencies in collaboration with the Arts Education Partnership.

Seidel, Steve. 1999. "Stand and Unfold Yourself: A Monograph on the Shakespeare & Company Research Study." In *Champions of Change: The Impacts of the Arts on Learning*, edited by Edward B. Fiske, 79-90. Washington, D.C.: Arts Education Partnership.

Shearin, Megan. 2013. "Tolerating Ambiguity inside the Creativity Classroom." William and Mary News and Media. https://www.wm.edu/news/stories/2013/tolerating-ambiguity-inside-the-creativity-classroom-123.php.

Slota, Margaret, Maureen McLaughlin, Lorena Bradford, Julia F. Langley, and Sarah Vittone. 2017. "Visual Intelligence Education as an Innovative Interdisciplinary Approach for Advancing Communication and Collaboration Skills in Nursing Practice." *Journal of Professional Nursing*, December. https://doi.org/10.1016/j.profnurs.2017.12.007.

Stoycheva, Katya. 2003. "Talent, science and education: How do we cope with uncertainty and ambiguities?" In *Science Education: Talent Recruitment and Public Understanding*, edited by Peter Csermely and Leon M. Lederman, 31-43. Burke, VA: IOS Press.

Styhre, Alexander, and Michael Eriksson. 2008. "Bring in the Arts and Get the Creativity for Free: A Study of the Artists in Residence Project." *Creativity and Innovation Management* 17 (1): 47–57. https://doi.org/10.1111/j.1467-8691.2007.00458.x.

# REFERENCES

Tatzel, Miriam. 1980. "Tolerance for Ambiguity in Adult College Students." *Psychological Reports* 47 (2): 377–78. https://doi.org/10.2466/pr0.1980.47.2.377.

Tiruneh, Dawit Tibebu, Xiaoqing Gu, Mieke De Cock, and Jan Elen. 2018. "Systematic Design of Domain-Specific Instruction on near and Far Transfer of Critical Thinking Skills." *International Journal of Educational Research* 87 (January): 1–11. https://doi.org/10.1016/j.ijer.2017.10.005.

Weinstein, Dina. 2011. "The Healing Arts." *Miami: The University of Miami Magazine* 18.1. http://www6.miami.edu/miami-magazine/fall2011/featurestory4.html.

Winner, Ellen, and Monica Cooper. 2000. "Mute Those Claims: No Evidence (Yet) for a Causal Link between Arts Study and Academic Achievement." *Journal of Aesthetic Education* 34 (3/4): 11–75. https://doi.org/10.2307/3333637.

Zeki, Semir. 2004. "The Neurology of Ambiguity." *Consciousness and Cognition* 13 (1): 173–96. https://doi.org/10.1016/j.concog.2003.10.003.

Zenasni, Franck, Maud Besançon, and Todd Lubart. 2008. "Creativity and Tolerance of Ambiguity: An Empirical Study." *The Journal of Creative Behavior* 42 (1): 61–73. https://doi.org/10.1002/j.2162-6057.2008.tb01080.x.

# SOURCE CITATIONS

In-text citations refer readers to the reference list above. Note that much of the research on arts integration is done with the K-12 population. We refer to that literature only when we deem that the impacts discussed are applicable to college-age students as well.

Examples from the SPARC interview data have an in-text citation indicating the unique identifier number of the quotation, but do not appear in the reference list. Each identifier has a prefix that begins with the letter "Q" and a number, indicating the question to which the speaker was responding.

Readers interested in the context for these examples can visit *Supporting practice in the arts, research, and curricula* (SPARC), 2012-2015, in the National Archive of Data on Arts & Culture. https://doi.org/10.3886/ICPSR36823.v1

Examples from the U-M Arts Engagement study also have an in-text citation but do not appear in the reference list. These examples are identified only by the question to which the speaker was responding. As of summer, 2019, the results of the UM Arts Engagement study are under review for publication. Study authors are Gabriel Harp, Debra Mexicotte, Jack Bowman, and Mengden Yuan.

**Image Credits:** Wassily Kandinsky, *Composition IX*, 1936; Wassily Kandinsky, *Composition VIII*, 1923.

## FOLLOW-UP: QUESTIONS FOR BUILDING UNDERSTANDING

Identify from your institution three examples of the types of impact in this report.

Identify three examples of these types of impact from somewhere else.

What experiences, methods, and/or practices help impacts related to student skills and capacities emerge?

How do these impacts manifest in different ways for different students?

What teaching and learning activities would be relevant for deepening particular impacts in this report?

What kinds of institutional barriers might get in the way of these impacts?

What kinds of incentives or programs could broaden the impacts of arts-integrative teaching, engagement, and/or research?

What counts as evidence for the impacts in this report? What challenges might those who do arts-integrative work face when seeking evidence or justification for these impacts?

## IMPACTS RESEARCH PROCESS: STAGE 1

The insights in this report are based on responses to the following questions in a2ru's SPARC (Supporting Practice in the Arts, Research and Curricula, funded by the Andrew W. Mellon Foundation) interview cycle, which took place 2012-2015.

*What impact did you hope to see? What impact did you actually see and how did you measure it?* (Question 25)

*How have these programs affected your teaching and research? What about your colleagues' teaching and research?* [and variations of this wording] (Question 26)

The interviews were recorded and transcribed, and a2ru staff parsed and cleaned the transcripts. There were 212 individual responses in which people talked about a range of experiences—from awards and recognition for innovative research, to strengthened student communities, to sensory gardens for the blind.

From these responses, we tagged every instance in which an interviewee identified an impact of their arts-integrative work and, in the service of distilling this large data set (273 examples), applied a bottom-up coding process. We grouped similar types of impact together, eventually developing a taxonomy of major categories of impact. Since most interviewees did not distinguish between intended and actual impacts, this data set becomes a catalogue of "possible impacts."

We found that the major categories we had identified differ in type. Some center on the object of impact, such as "impact on the community" or "impact on research," and some seem more action-centered, such as "generates involvement and enthusiasm" or "promotes community and collaboration." To make sense of the data, we constructed roles for and relationships among the categories, generating an organizational structure that is fully represented in the comprehensive report on impacts and in the graphic map of impacts, and partially represented in shorter, targeted reports such as this one. Our sense-making, as articulated in this structure, is, of course, inductive and subjective; there are alternative ways of telling the story of this data.

## SPARC DATA SAMPLE INFORMATION

The 155 respondents to these two questions were primarily faculty (79%), but also included those in leadership roles at the Director, Dean, and Provost levels (17%), as well as other staff such as curators and librarians. Notably, half of those who identify as Professor also serve in leadership roles. Eighty-eight per cent of those interviewed worked at Research 1 or Research 2 universities, with the remainder at colleges and universities with larger Master's programs, arts-focused four-year schools, and universities with very high research activity.

SPARC interviewees represented disciplinary clusters as follows:

| | |
|---|---|
| Music, Theatre, and Dance | 27% |
| Fine, Contemporary, and Media Arts | 21% |
| Engineering, Design, Information, and Architecture | 18% |
| Humanities | 15% |
| Natural Sciences and Medicine | 10% |
| Social Sciences, Education, Business, and Law | 8% |

# IMPACTS RESEARCH PROCESS: STAGE 2

In 2018, we supplemented and expanded our impacts taxonomy with a literature review and an additional data set — the four-year longitudinal Arts Engagement study of ~4000 undergraduates at the University of Michigan.

As a result of this supplementary research, we revised some aspects of our structure, including the identity of high-level categories and the relationships among those categories. In addition, we added new sub-categories and examples of impact to our taxonomy. However, readers should note the difference in process between the SPARC research and this supplemental research, and how it manifests in these reports. The original, interview-based research followed a bottom-up process, in which examples—quotations drawn from interviews—formed the foundation. We gathered together examples that were similar in type, and these eventually formed sub-categories, which coalesced into categories. By contrast, with the literature review, we sometimes found categories of impact suggested by research that didn't have accompanying examples (a more top-down approach). Because of this, the reader will notice that some categories of impact are rich with real-life examples while others have theorizing but no examples. Both types serve the goal of the taxonomy—to describe the rich landscape of impacts—even though the narrative representation varies.

## ARTS ENGAGEMENT DATA SAMPLE INFORMATION

Interviewees were University of Michigan undergraduate students who responded to questions about the arts in their college experience. This report draws on the following questions from that survey:

*In what ways do you think you can grow through the arts?*     n=971

*What role did the arts play in your development as a person, friend, colleague, and student during college?*     n=840

## FUTURE QUESTIONS AND DIRECTIONS FOR RESEARCH

**How can we mobilize existing knowledge to broaden our understanding of the impacts of arts integration?** What other research overlaps this investigation, allowing the appropriation of relevant findings? What useful perspectives can sociology, psychology, game theory, business, history, and countless other domains lend to this research?

**How can we delve deeper into the impacts in this report? How could we establish a causal relationship (not just a correlative one) between arts-integration and a single impact such as increased leadership skills?** Could a small-scale longitudinal study go even further, providing not only evidence of causality but even an explanation of how that impact is effected? What other means exist for learning more about the impacts we have discovered?

**How can we develop an effective measurement of impact? What tools, methodology, and evidence are appropriate for demonstrating impact?** How might new information about the scope or type of impact, obtained through measurement, feed back into the work we do?

**How is the picture presented in this report incomplete?** What impacts are missing, and where are the gaps? What impacts of arts integration and interdisciplinarity need to be surfaced and addressed?

**How else might the impacts data be structured?** We have assigned roles and relationships to individual pieces of data and built an organizational structure around them. What are alternative ways to tell the story of the data?